IMAGES
of America

GALVESTON'S THE ELISSA
THE TALL SHIP OF TEXAS

The Texas flag flies proudly overhead as volunteers of the *Elissa* furl the sails. Men and women from all walks of life undertake a grueling eight-month course to learn to sail the ship. Without their dedication and hard work, the *Elissa* would never leave the dock. (Courtesy of Galveston Historical Foundation.)

ON THE COVER: The iron barque *Elissa* sails the waters of the Gulf of Mexico every year. Peter Stanford, president emeritus of the National Maritime Historical Society, wrote of the vessel: "Indeed, the restoration of this graceful barque of 1877 is reckoned by many to be the finest restoration of an active sailing ship extant." (Courtesy of Kraig Emmert.)

IMAGES *of America*

# GALVESTON'S THE *ELISSA*
## THE TALL SHIP OF TEXAS

Kurt D. Voss

ARCADIA
PUBLISHING

Copyright © 2009 by Kurt D. Voss
ISBN 978-0-7385-7855-2

Published by Arcadia Publishing
Charleston SC, Chicago IL, Portsmouth NH, San Francisco CA

Printed in the United States of America

Library of Congress Control Number: 2009930504

For all general information contact Arcadia Publishing at:
Telephone 843-853-2070
Fax 843-853-0044
E-mail sales@arcadiapublishing.com
For customer service and orders:
Toll-Free 1-888-313-2665

Visit us on the Internet at www.arcadiapublishing.com

*This book is dedicated to everyone who has loved and cared for the
Elissa, past, present and future, and to Lisa Gould, who understands.*

# CONTENTS

| | | |
|---|---|---|
| Foreword | | 6 |
| Acknowledgments | | 7 |
| Introduction | | 8 |
| 1. | "An Arab Steed in a String of Cart Horses" | 11 |
| 2. | The Slow Decline | 23 |
| 3. | "Things the World Cannot Afford to Lose" | 35 |
| 4. | "Queen City of the Gulf" | 43 |
| 5. | A Tall Ship for Texas | 49 |
| 6. | The *Elissa* Sails! | 83 |
| 7. | Keeping the Dream Alive | 107 |
| Glossary | | 125 |
| Particulars of the 1877 Barque *Elissa* | | 126 |
| About the Organization | | 127 |

# Foreword

As a child, my father and aunts would only tell me *Elissa* was sold into the Baltic trade; we do not speak about it. The traumatic destruction of their father's sanity and the family fortune was old history by my birth in 1926. My grandfather, Henry Fowler Watt, born in 1839, remained an intriguing Victorian mystery.

David Watt, my brother, had studied the Watt story when he was a Washington correspondent of the *Financial Times* and planned to visit *Elissa* in Galveston when taking up his Truman Fellowship to complete his book on Anglo–U.S. relations since World War II. His untimely death through a tragic accident in 1987 left me to pick up the *Elissa* connection, my mother being then too old.

I visited *Elissa* in 1994 to give a talk about my grandfather to the Galveston Historical Foundation and give the Texas Seaport Museum some mementoes and photographs, a selection reproduced in this book. In 1995, my husband and I had the privilege of sailing in *Elissa*, steering and handling her, and admiring both the skill and determination of her restorers and the loving dedication of her volunteer crew.

The orphaned boy, sent to sea at 16 by his stepfather, Dr. John Carlyle, hero-worshipped that man's brother, the famous Thomas Carlyle, who often befriended him on leave. On his elder brother's early death, he inherited his father's Cheshire estate, bringing his young wife, Jane Hunter, from Craigcrook Castle outside Edinburgh to Liverpool. He had then three sailing ships and a dearly loved steeplechaser, which he raced himself.

Eight children later, he commissioned the *Elissa* from Alexander Hall's Aberdeen yard just before his last child's birth—my father, John Watt. Although 1877 was no time to invest in sail, for the next two decades he found niches in the carrying trade, though increasingly infrequent. Luckily, he twice visited Galveston—and the rest is history.

Short, fearless, eccentric, outspoken, and a total perfectionist, Henry Fowler Watt was also a devoted husband and father. This experienced master mariner was also president of his Liverpool Association and a skilled craftsman in wood and metal. He was never a good businessman, and the hardening of the arteries of his brain gradually affected his judgment and behavior before his final breakdown. It still took 12 years and four strokes to end the life of this tough seaman in 1913.

His passionate love for the perfect sailing ship has left a legacy now safely registered as a National Historic Landmark. One hundred and seventy years from his birth, on behalf of the whole Watt family, I wish *Elissa* calm seas and a prosperous voyage into the future.

—Marjorie Lyle (née Watt)
Canterbury, Kent, United Kingdom
March 2009

# Acknowledgments

This book was written because of the vision and tenacity of the Galveston Historical Foundation. The restoration of the *Elissa* required uncommon courage and determination, traits still exhibited by the organization's willingness to keep the ship sailing. I would particularly like to thank executive director Dwayne Jones, who provided the opportunity to document the transformation of this remarkable vessel.

I would also like to thank the staff and volunteers of the organizations who helped compile these photographs, especially Greg Brannan, Dennis Dornfest, Kraig Emmert, Christine Hayes, Becky Jones, Beth Karna, Phil Niewald, Judy Ryan, John Schaumburg, and Charles Volek, all of the Texas Seaport Museum; Jennifer Marines and Jodi Wright-Gidley of the Galveston County Historical Museum; and David Hull, Steve Hyman, Bill Kooiman, and Jamie White of the San Francisco Maritime Historical Park. Special thanks go to John Moran for his invaluable help in all aspects of this book and to Ted Keiler for his encouragement and inspiration.

Likewise, I appreciate the material received from descendants of people who sailed in the *Elissa* during her many lives: Anders Ekvoll, Berndt and Kerstin Eliasson, Erik Hag, Henrik Karlsson, and the Nylund family. I am extremely grateful to Marjorie Lyle for writing the foreword and going to such lengths to reproduce material from her grandfather Henry Fowler Watt. I will always treasure her visits to Galveston in 1994 and 1995, when she donated a number of family artifacts to the Galveston Historical Foundation.

Many photographers contributed to the *Elissa* archives over the years, but David Canright, Jim Cruz, Kraig Emmert, and Doug Manger deserve special mention. It was difficult to choose a limited number of photographs from so much good material. Unless otherwise noted, all images appear courtesy of the Galveston Historical Foundation.

The kind, patient editorial staff at Arcadia Publishing have earned special thanks as well, especially my editor, Kristie Kelly. It has been a pleasure to work with such talented professionals.

Finally, of the many people who played crucial roles in resurrecting the *Elissa*, Capt. Walter Rybka is probably most responsible for the uncompromising standards to which the ship was restored. For decades, he has been my chief mentor and an invaluable source of knowledge and advice.

# INTRODUCTION

In July 1979, an unusual illustration appeared in the *Houston Chronicle*. It showed a painting of an elegant three-masted barque, with all 19 of her sails set, leaving a busy port and heading for deep water and foreign lands. The article was about the 1877 sailing vessel *Elissa*, purchased in 1975 by the Galveston Historical Foundation. After many preservation successes on shore, the foundation wanted to restore one of the ships that created the wealth that, in 1900, gave Galveston one of the highest per capita incomes of any city in the United States. After an exhaustive search, researchers discovered that in 1883 and 1886 the *Elissa* had loaded cotton in Galveston, bound for Liverpool, England. A century later, her hull was finally sound enough to be towed from Piraeus, Greece, where she had narrowly escaped the scrapper's yard. The *Elissa* was finally coming home.

What began as a wild dream became a reality when the *Elissa* opened to the public on July 4, 1982. After a two-year do-or-die effort, she was transformed back to the splendor of that early painting. The following month, at the end of August, she took to the sea again under sail—for the first time in decades.

This book is a photographic chronicle of that remarkable transformation. Rare and forgotten photographs, many of which have never been published, tell the story of the *Elissa*'s various lives, beginning with Henry Fowler Watt, the man who commissioned her construction. Watt's fortunes—and the *Elissa*'s—paralleled all late-19th-century sailing ships. By the 1890s, steamships were driving their wind-powered sisters from the world's oceans. After a ruinous voyage in 1897, Watt ran out of money and was forced to sell the *Elissa* to the Norwegian firm of Bugge and Olsen.

Her sojourn in Scandinavia lasted until 1959, as she was passed along to a variety of Swedish and Finnish owners. She received the new names of *Fjeld* and *Gustaf*, and her rig was progressively reduced until, by the 1940s, she was just a motor ship. Despite this long decline, her caretakers always considered her special, particularly her captains.

The *Gustaf* was sold to Greek owners in 1959, moved to the Mediterranean, and received yet another name, the *Christophoros*. Sailing out of Piraeus, she continued the same trade she had always known: carrying whatever cargoes her owners could find to keep the ship viable. That task became increasingly difficult, and she wound up in the hands of smugglers who were illegally importing cigarettes from Yugoslavia to Italy. Now named the *Achaios*, her new owners considered her expendable. If caught at sea with illicit cargo, her crew would scuttle her before the authorities could board the ship. By 1969, she was so notorious that the Italian government made official complaints about her activities to the Greek and Yugoslav authorities. Another name change, this time to the *Pioneer*, and altering the configuration of her profile failed to fool anyone. In October 1970, she was anchored alongside a ship waiting to be scrapped, a fate she would soon share if no one stepped in to save her. Salvage was the only means left to the smugglers to squeeze any more income from her.

Thankfully, such dreamers existed and had been working for years to save the *Elissa*. Marine archaeologist Peter Throckmorton came across the ship in 1961 while delivering a motor launch to Piraeus. His trained eye recognized the hull of a sailing ship, confirmed by the lines of chain plates to which the rigging had been attached. Her captain invited Throckmorton to the officers' accommodations, where the original builder's plate had been moved from the mizzenmast to an engine room ventilator. The plaque read "Alexander Hall & Co, No. 294, Aberdeen, 1877." Throckmorton wrote to Hall—one the world's premiere shipbuilders—who was still in business. As he suspected, Hall confirmed that the *Christophoros*, the ex-*Elissa*, had indeed been built as a square-rigger. Throckmorton, busy making a living, filed this information away, thinking that perhaps one day this old vessel would make an interesting platform for his underwater archaeology work.

Unaware of Throckmorton's activities, Karl Kortum, director of the San Francisco Maritime Museum (now the San Francisco Maritime National Historical Park), had been trying to save the *Elissa* since 1964. Kortum, one of the deans of the historic ship preservation movement, first learned of the *Elissa* in the course of helping a local broadcaster named Jack Capell bring a tall ship to Portland, Oregon. That project was ultimately abandoned, but Kortum could not forget the ship that he described as "unquestionably the last specimen of the small iron British deepwaterman still afloat on the face of the earth." Kortum diligently tried to find a home for the *Elissa* in Monterrey, California, and San Francisco but was unable to generate a commitment from either community.

In January 1969, Peter Stanford, president of South Street Seaport Museum in New York, compared the stories of Kortum and Throckmorton, and put them in touch with each other. As Stanford wrote in 1979: "From that point on, Throckmorton and Kortum worked as partners to save the ship." Throckmorton agreed to act as Kortum's agent, while Kortum tried to develop a plan to buy the vessel.

The situation became desperate in October 1970 when Throckmorton discovered the *Pioneer* (ex-*Achaios*, ex-*Christophoros*, ex-*Gustaf*, ex-*Fjeld*, and ex-*Elissa*) was anchored next to an island freighter waiting to be scrapped. He contacted Kortum to advise him that their time was up; if they were going to save the ship, they must do it now. Kortum, a real hero in the *Elissa*'s rescue, managed to scrape together the $13,500 purchase price. Bill Roth, described by Kortum as, "an enlightened member of the museum board," donated $5,000. The remaining $8,500 came from ticket sales for the sailing ship *Balclutha*, one of the San Francisco Maritime Museum's star attractions.

Before they could secure ownership, however, the transaction had to be cloaked in secrecy. Knowing that the selling price would rise to an impossible level if the smugglers knew an American museum was buying the ship, Throckmorton and his Greek cohort, Grigori Mentis, posed as if they wanted to do something shady with the vessel. Part of that process involved Throckmorton mortgaging his schooner, the *Stormie Seas*, to raise the necessary cash until Kortum could reimburse him (funds wired from the United States might have tipped off the smugglers). These arrangements were made via telegram and telephone, which meant that Throckmorton put his home and means of support at risk based on what was essentially an electronic handshake.

Although the ship had been saved for the time being, San Francisco could not afford to restore her—and the *Elissa* was still on the other side of the world. Kortum redoubled his efforts to find a permanent home and an organization with the means to restore the ship to her former glory.

For a time, it appeared that he had located just such a group when David Groos, a member of the Canadian Parliament, spearheaded efforts to bring the *Elissa* to Victoria, British Columbia. Groos purchased the ship in 1972, but once again, reality shattered the dream. Groos had a difficult time finding the support he needed, and then, not long after buying the *Elissa*, he died of cancer. The plan to bring a tall ship to Victoria died with him, and the ship was put up for sale.

Who would have dreamed that a bunch of hardheaded Texans, willing to do and spend whatever was necessary, would finally be the ones to transform the *Elissa* from an Aegean smuggler to a graceful barque with billowing canvas? The entire story of how that came to be is too long for these pages, but Karl Kortum provides an excellent summary of how it started:

Michael Creamer, who ran the ship model shop at South Street [Seaport Museum], met Paul Gaido during a visit to Galveston and heard that forward-looking citizen's ideas about building a replica [of] Jean Lafitte's pirate schooner. Creamer had indoctrination in real ships, not replicas, at South Street and he urged Gaido in that direction. Norman Brouwer was consulted; he pointed to the *Elissa* in Greece. Creamer wasn't much impressed with this motorship-looking vessel. Then Norman got the notice that the Victoria location had fallen through and that she was for sale. With it was a copy of the "Lloyd's List of Movements and Casualties" that we had obtained from the London agency. It showed a visit to Galveston in 1883 and another in 1886.

Gaido and Creamer approached Peter Brink, executive director of the Galveston Historical Foundation, who liked the idea of having one of the ships that made possible all the 19th-century homes and buildings that were being restored. The organization had achieved much success in leading those efforts. Brink believed that an authentic sailing ship a block away from the Strand, once called "the Wall Street of the Southwest," would be a perfect complement to the landmark historic preservation happening ashore.

On October 2, 1975, the Galveston Historical Foundation purchased the *Elissa* for $39,000. A year later, the foundation sent a team to Greece with the hope of spending approximately $100,000 more to partially restore the ship and sail her to Galveston under a reduced rig. Once she returned to Galveston, some believed that she could be fully restored for an additional $100,000. When the *Elissa* finally sailed in August 1982, the Galveston Historical Foundation had invested $4.5 million in the vessel.

Since then, the project has grown into the Texas Seaport Museum, with a shoreside museum building, a workshop, award-winning education programs, and a number of additional vessels and boats. A devoted group of volunteers, aided by a very small but equally dedicated paid staff, keep the ship alive. Today the *Elissa* remains a worldwide benchmark of maritime preservation. On June 8, 2005, Gov. Rick Perry signed a resolution naming the *Elissa* the "Official Tall Ship of Texas."

The story of the *Elissa* involves much more than the technical aspects of building, restoring, and maintaining a 19th-century sailing vessel. Throughout her life, extraordinary people have poured their heart and soul into her—and they still do. Henry Fowler Watt expended a family fortune to build her and keep her sailing. Herman Andersen, her master when she was the *Fjeld*, passed down his deep affection for the ship to his descendants, who still consider the *Elissa* to be part of their family. Karl Kortum put his career at stake to save the *Elissa* and find her a viable owner. Peter Throckmorton mortgaged the *Stormie Seas*—his home and means of livelihood—to help Kortum purchase the *Elissa* from the smugglers who would have scrapped her. Paul Gaido, a Galveston restaurateur and civic leader, put his hard-earned respect in the community at stake to bring the *Elissa* to Texas. Peter Brink, executive director of the Galveston Historical Foundation, made the bold decision to acquire the ship in the face of much opposition. Director David Brink saved the project from oblivion when it was in very real danger of being abandoned. Walter Rybka, the ship's restoration director, worked incessantly and brilliantly for years to ensure that the *Elissa* was restored to the standards she deserved. Jim Story, like many volunteers who followed him, essentially took on a second, unpaid, full-time job to found and manage the ship's volunteer program, which is still considered a national standard. These people, and many others, exemplify the passion and dedication that the *Elissa* has inspired from the time of her launching to the present day.

Thankfully, we have more than period paintings and photographs to commemorate one of the ships that helped settle Texas. We have the authentic artifact, what Peter Stanford called "the testimony of the thing itself." The voyage upon which the *Elissa* embarked in 1877 is ongoing. As long as her caretakers continue to provide the care she merits, it will never end.

# One

# "An Arab Steed in a String of Cart Horses"

*At the first glance I saw that she was a high-class vessel, a harmonious creature in the lines of her fine body, in the proportioned tallness of her spars. Whatever her age and her history, she had preserved the stamp of her origin. She was one of those craft that in virtue of their design and complete finish will never look old. Amongst her companions moored to the bank, and all bigger than herself, she looked like a creature of high breed—an Arab steed in a string of cart horses.*

—Joseph Conrad
*The Shadow-Line*

The *Elissa* has always been extraordinary. Even in the late 19th century, when sailing ships were ever-present, knowledgeable mariners would have immediately recognized her as one of Joseph Conrad's "high-class vessels." Such standards of quality and character did not happen by accident.

Henry Fowler Watt commissioned the *Elissa*'s construction in 1877 and owned her for 20 years. According to his son, John Hunter Watt, Henry was a perfectionist, insisting that everything about the five ships he owned "was of the best." Watt was 38 years old when he had the *Elissa* built by Alexander Hall and Company of Aberdeen, Scotland, one of the world's finest shipbuilders. Not content with a high pedigree, Watt had the *Elissa* built under Lloyd's special survey, meaning she was inspected far more often than was necessary to receive her registration. When she was completed, she received the Lloyd's designation 100A1, the highest possible classification. Watt also lavished funds on other details that were not customary for a vessel of this size, such as the magnificent hardwood paneling in the officers' accommodations.

During Watt's ownership, the *Elissa* travelled the world's oceans, carrying whatever cargoes he could secure for her. As steamships pushed sail aside, Watt was finally forced to sell the ship after heavy damage in an 1897 North Atlantic gale. By all accounts, it must have broken his heart.

Karl Kortum learned of this painting in Oslo's Norsk Sjofarts Museum while "pedigree-chasing" (researching the ship's history). It depicts the *Elissa* as the *Fjeld*, the name given to her after she was sold in 1897. A decade later, the work was acquired by the Galveston Historical Foundation and sent out for preservation. Art conservators discovered that the name *Elissa* and the flag of the British Merchant Service had been painted over. Art historians believe the painting was done by noted marine artist Edouard Adam when the *Elissa* was built, then altered by the new owners.

> ABERDEEN—LAUNCH OF A BARQUE.—On Saturday afternoon, a barque of 450 tons register, of the highest class at Lloyd's, was launched by Messrs A. Hall & Co., Aberdeen. The barque, which was built to the order of Mr H. Watt, of Liverpool, is intended for the West Indian trade. She was named the Elissa.

Notice of the *Elissa*'s launching appeared in the October 29, 1877, edition of the Edinburgh newspaper the *Scotsman*. The ship sailed from Cardiff for Pernambuco on December 19, less than two months after she was launched on October 27.

The preeminent firm of Alexander Hall and Company, founded in 1790, was known for their fast, high-quality vessels. A number of the men in this 1862 photograph were probably involved in the *Elissa*'s construction 15 years later. William Hall (standing, fourth from right, with his hand in his watch pocket) was the main designer. James, his younger brother (standing, second from right), was in charge of construction.

The home of Alexander Hall and Company was Aberdeen, Scotland, whose harbor is shown here around the time of the *Elissa*'s launching. (Courtesy of the Aberdeen City Libraries.)

According to his granddaughter, the family of Henry Fowler Watt (1839–1913) "had prospered less from trade than from prudent marriages to heiresses." He used his inherited fortune to own and operate five sailing ships during his life: the *Eliada*, the *Margaret Wilkie*, the *Elice*, the *Elissa*, and the *Elvira*. Watt went to sea as an apprentice, probably at age 14 or 15, passed his master's license at age 28, and then became a ship owner about 10 years later. (Courtesy of Marjorie Lyle.)

During Watt's ownership, the *Elissa*'s home port was Liverpool, England. Queen's Dock appears below in this photograph from the 1880s.

Watt's mother, Phoebe Hough Fowler Watt Carlyle, was age 21 when this portrait was made. The daughter of a wealthy banker, she married Fitzjames Watt in 1837. After honeymooning in Rome, the couple settled into a comfortable life until Fitzjames died of tuberculosis in 1848. (Courtesy of Marjorie Lyle.)

Phoebe Watt married physician John Carlyle in 1852, an old family friend and brother of the famous Scottish essayist and social commentator Thomas Carlyle. A year later, Phoebe died in childbirth, following injuries suffered after a railway mishap. Her four sons, Thomas, Henry, William, and Arthur, became wards of John Carlyle. By that time, the young Henry, age 16, was already an apprentice at sea with the East India line. (Courtesy of Marjorie Lyle.)

Henry Fowler Watt continued a family tradition of marrying well when he and Jane Hunter were wed in 1863 at Craigcrook Castle, the Hunter family estate outside of Edinburgh, Scotland. Watt entered into a "family of lawyers, professors, and ministers [that] were part of Edinburgh's silver age." (Courtesy of Marjorie Lyle.)

Below, this locket belonged to Jane Hunter Watt; the photograph inside is of Henry Fowler Watt. It is now part of the collection of the Texas Seaport Museum thanks to the generous donation of their granddaughter Marjorie Lyle.

When the *Elissa* was built in 1877, Henry Fowler Watt and his family lived at Victoria Park, Wavertree, Liverpool. Jane and Henry Watt had six daughters: Jane, Rebecca, Phoebe, Susan, Helen, and Margaret. At least one of them shared Henry's sense of wanderlust: Phoebe became the matron of a British Army hospital on the northwest frontier of India. (Courtesy of Marjorie Lyle.)

An undated family portrait shows, from left to right, Henry Fowler Watt; his wife, Jane Hunter Watt; Jane's sister Henrietta Hunter Watt; their mother, Helen Vary Hunter; Arthur Watt (Henry's brother and Henrietta's husband); and Mary Watt and her husband, William Watt (Henry's youngest brother). The brothers Henry and Arthur Watt married the sisters Jane and Henrietta Hunter at a double wedding in 1863. (Courtesy of Marjorie Lyle.)

The exact circumstances of this intriguing photograph of Henry Fowler Watt are unknown. It appears to commemorate a particularly fast passage made by Watt: "The 50-day run to Australia." is written on the back. "A very domestic man," written on the front, is in the handwriting of Watt's wife, Jane. (Courtesy of Marjorie Lyle.)

When Marjorie Lyle visited her grandfather's ship in Galveston in 1994, she donated this extraordinary artifact to the Texas Seaport Museum. It is Henry Fowler Watt's first master's license, issued to him in 1867. After Watt became a ship owner, he spent more time ashore than at sea. He was captain of the *Elissa* in 1885 when he took the ship from Rangoon to Cape Town, and then again from 1895 to 1897, during the ship's last voyage under his ownership.

Painstaking research by Walter Rybka produced all of the *Elissa*'s crew agreements from 1877 to 1897, which was a rare find. These records were often destroyed after a ship was sold or scrapped. They help personalize the ship by listing the names of the officers and sailors, what they were paid, how long they served, and where they were from. The *Elissa*'s normal complement was a captain, two mates, one or two apprentices (teenaged boys training to be officers), and eight seamen. Today the *Elissa* sails with five officers and about 40 crew.

The life of a 19th-century sailor was hard, dangerous, and not at all lucrative. When the wind rose, the crew had to climb the masts, lay out onto the yards, and stand on narrow lengths of wire rope to furl the sails. The worst conditions were found around Cape Horn, off the tip of South America, where ice might cover the rig. The *Elissa* made the Cape Horn passage a number of times. This photograph was taken off the Horn in the 1920s aboard the barque *Garthsnaid*. (Courtesy of San Francisco National Maritime Historical Park.)

Watt's primary affections lay with sailing ships, but he was also passionate about horses. His favorite was named "The Brill," perhaps shown in this photograph with Watt astride. (Courtesy of Marjorie Lyle.)

Henry Fowler Watt was a prolific writer, as well as a mariner and horseman. Many of his articles, letters, and speeches can be found in the journals of the Mercantile Marine Service Association (he was vice president of that organization in 1885) and newspapers such as the *Liverpool Critic*. In 1878, he published *The State of the Navy*, a stinging rebuke of the Royal Navy. It sold enough copies to warrant a second edition in 1879. This copy, signed by Watt, was donated to the Texas Seaport Museum by Marjorie Lyle.

THE

STATE OF THE NAVY,

1878.

UNARMOURED SHIPS.

BY

HENRY F. WATT,
MASTER MARINER.

SECOND EDITION.

LONDON:
GEORGE PHILIP & SON, 32, FLEET STREET.
LIVERPOOL:
WILLIAM POTTER, 30, EXCHANGE STREET EAST.

1879.

Unable to afford a captain, Watt took command of the *Elissa* in 1895, on a voyage that was doomed by fate. In December 1896, he put into Key West short of provisions. On January 25, 1897, while bound for England, Watt shot his mate, Samuel Donald, claiming mutiny. Donald was not seriously wounded and brought charges against Watt, who was exonerated. The final blow came on February 23, when the *Elissa* was heavily damaged in a North Atlantic storm. She was towed into Ventry, Ireland, unable to proceed under her own power after losing sails, wheel, binnacle, bulwarks, small boats, and davits. (Courtesy of Marjorie Lyle.)

Watt moved the *Elissa* to Havre for refitting, which may have included the wooden binnacle shown here, which was returned to the *Elissa* in 2000 through the generosity of Harry and Francis Brown. The cost of the refit (detailed in this 1894–1900 account book shown above), combined with a mortgage due on the ship, finally forced Watt to sell the *Elissa*. (Courtesy of Greg Branan.)

In 1994 and 1995, Marjorie Lyle (pictured below) visited the ship her grandfather had influenced so much. Through her research and generous donations, the Galveston Historical Foundation received vital insights into the man who began the *Elissa*'s long sea career. At age 69, Marjorie Lyle sailed in the ship, taking the wheel for a time and gamely going aloft to help furl sail. She is the second person on the left, standing on the footrope of the *Elissa*'s lower fore yard. (Both, courtesy of Marjorie Lyle.)

# Two

# THE SLOW DECLINE

As difficult as it must have been for Henry Fowler Watt to sell the *Elissa*, the decision proved to be in the best interest of the ship. Her new owners, Bugge and Olsen of Larvik, Norway, did not have to follow the more restrictive regulations of the British Merchant Service, allowing the company a better opportunity to make a profit. From 1897 to 1912, the *Elissa*, renamed the *Fjeld* ("mountain" in Norwegian), retained her barque rig and continued to sail much the same routes as she had under Watt's ownership. Her usual voyages were from Europe to Mexico and South America, although she made two more trips around the world. As Patricia Bixel wrote of the ship during this period, "she continued to be an extremely well run, seaworthy, lucky ship."

On February 26, 1912, she was sold to Holmström and Company, the first of many Swedish and Finnish owners. Now named the *Gustaf*, she was reduced to a barquentine in 1914 or 1915 (square-rigged only on the foremast rather than with square sails on the mainmast, too). A few years later, in 1918, she received her first engine.

Because square sails require more labor to set, furl, and adjust than fore and aft sails, subsequent owners reduced the rig even further (a simplified rig required fewer crew, hence, less payroll). By the 1920s, she was a three-masted schooner (with no square sails), plying the waters of the North Sea and the Baltic. Her graceful clipper bow was snubbed off in 1936, and she became largely a motor vessel, setting only a few sails between the masts.

The *Gustaf*'s long stay in Scandinavia came to an end in December 1959, when she was sold to A. Kavadas and D. Vassilatos of Piraeus, Greece, and named the *Christophoros*. She moved to the Mediterranean sometime in 1960 and traded among the Greek islands, doing the work she had always known, carrying whatever cargoes her owners could find. She was sold several more times until finally finding herself in the hands of smugglers, to whom the ship was merely an expendable platform for their crime. By 1970, she was in very real danger of being scrapped.

Experts such as Capt. Walter Rybka believe this is the only known photograph of the *Elissa/Fjeld* with her barque rig. The image is from a postcard sent from Laguna, Mexico—a port visited often by the *Fjeld* between 1898 and 1911.

Capt. Herman Andersen was the primary master of the *Fjeld* while the Norwegian firm of Bugge and Olsen owned her. Two of his grandsons, Anders and Tom Ekvoll, visited the restored *Elissa* in 2005. Having grown up with the exploits of Captain Andersen and the *Fjeld*—the source of much family pride—the two men were moved to tears when they finally walked the decks of the ship they believed had been scrapped long ago. (Courtesy of Anders Ekvoll.)

Ferdinand Bertinius Pedersen, a sailor aboard the *Fjeld* in 1910, first went to sea at age 14. A few years after sailing in the *Fjeld*, Pedersen died of appendicitis and was buried at sea off the coast of South Africa. (Courtesy of Tonnes Gundersen.)

On March 9, 1910, while in Preston, England, Ferdinand Pedersen sent this postcard to his parents in Norway. The image on the postcard comes from a painting of the *Fjeld* done by renowned marine artist T. G. Purvis. The work was commissioned by Capt. Herman Andersen and remained in his family until 2005. (Courtesy of Tonnes Gundersen.)

On the back of the postcard to his parents, Ferdinand Pedersen wrote this poem about the *Fjeld*: "On this ship / I will rock on the / Big proud ocean and / Endure many storms / That will cross its stern / While I stand at the wheel / And look at the mild glow / Of the stars / Then I hum / My song about / The little Norway with the cliffs / That I like best." (Courtesy of Tonnes Gundersen.)

The *Fjeld* became the *Gustaf* after being sold to Swedish owners in 1912. During the winter of 1914–1915, the square sails on the mainmast were removed, changing the ship from a barque to a barquentine. This photograph was taken soon after that transition. Although a number of surviving images show the *Gustaf* as a barquentine, this is the only one with the royal yard still attached to the foremast. (Courtesy of Berndt Eliasson.)

After being powered only by the wind for 40 years, an engine was fitted in late 1917 or early 1918. An unidentified photographer captured this rare image while the *Gustaf* was hauled out during that installation. (Courtesy of Sjofarts Museum, Gothenburg, Sweden.)

In the years before and after World War I, as she continued to trade in North Sea and Baltic ports, the *Gustaf* received subtle changes to her sail plan. Above, the royal yard has been removed from the foremast, but the brailed spanker remains on the mizzen, a remnant from her days as a barque. Below, at Aakaos in 1921, a smaller triangular-shaped sail is set on the mizzen to balance the helm and offset the reduction in sail on the fore. (Above, courtesy of Berndt Eliasson; below, courtesy of Lars Gronstrand collection.)

Carl Victor Eliasson, shown here as a teenaged apprentice, must have been a talented captain. He was the master of the *Gustaf* from 1912 to 1919, during which period the ship was sold at least three times. Each new owner decided that Eliasson should remain in charge of the vessel. (Courtesy of Berndt Eliasson.)

The afterguard of a ship somewhat larger than the *Gustaf* are enjoying a meal on the quarterdeck sometime during World War I. Captain Eliasson is seated on the left in front of the wheel. (Courtesy of Berndt Eliasson.)

Of the many photographs taken of the *Elissa* during her long life, these are the only images known to exist that include a view of the deck and a shot of the crew while she was still a square-rigged sailing ship. This *c.* 1914 photograph comes from the collection of Carl Victor Eliasson, the ship's captain during that time. The names of the people on board are unknown; the gentleman in the bowler hat and tie may be one of the ship's owners. The booms and cargo handling gear at the base of the mainmast were still relatively new when this photograph was made, having been added during the ship's recent conversion from a barque to a barquentine. (Both, courtesy of Berndt Eliasson.)

By the 1920s, the Gustaf had been converted to a simple schooner with no square sails on any of her masts. During the 10-year span between these two photographs, the bowsprit has been shortened, possibly due to several collisions the ship suffered. The picture below is from the album of Hugo D. Karlsson, one her captains during the 1930s. (Above, courtesy of Erik Hag; below, courtesy of Henrik Karlsson, Åland Maritime Museum.)

The *Gustaf* came under Finnish ownership when Erik Nylund of Mariehamn bought the ship on October 31, 1929, on behalf of several partners. Gustaf Erikson, who owned many of the world's surviving sailing ships in the 1930s, had a minority interest of 45 percent. According to Henrik Karlsson, director of the Åland Maritime Museum in Mariehamn, Finland, Erikson strenuously objected when the ship was sold in 1936, but he was overruled by the majority owners. (Courtesy of the Nylund family collection.)

The *Gustaf* continued to soldier on, still carrying cargo to northern European ports, sailing under her schooner rig with an auxiliary engine. She appears to be reasonably well kept and in good condition in this photograph (below), taken in the early to mid-1930s. (Courtesy of Henrik Karlsson, Åland Maritime Museum.)

The *Gustaf* suffered extensive damage to her starboard bow following a collision with the steamer *Gerania* on October 18, 1931. Similar accidents during the prior decade may have contributed to the removal of her clipper bow and bowsprit in 1936. That year, a deckhouse was also built atop the quarterdeck on the stern of the ship. By this time, she relied mostly on her engine, with only a few sails remaining between the masts. (Courtesy of the Nylund family collection.)

Although this photograph was taken at Antwerp in 1954, the *Gustaf* looked much the same when Dorothy Laird wrote about a visit to the ship in London in 1951: "A new and ugly steamer bow replaces the jibboom, but the lines of the counter be unchanged, although a Baltic deckhouse be built over the poop. . . . The companionway below be still steep and twisting, each step edged handsomely in brass. And the master's saloon . . . is much as it was originally."

The *Gustaf* was sold to Greek owners in December 1959 and became the *Christophoros*. A few months later, she left northern Europe for Piraeus, her new home port. Coastal operations in the Greek isles kept alive many old ships. (Courtesy of San Francisco National Maritime Historical Park.)

By the late 1960s, the *Elissa*, now named the *Achaios*, had become an outlaw, smuggling cigarettes from Yugoslavia to Italy. In the hope of masking her notoriety, the owners altered her profile, adding a false bulwark to the bow and substituting a single midship mast for the ones fore and aft. The modifications, along with one more name change, to the *Pioneer*, did not fool the authorities. In 1970, she was laid up alongside a ship waiting to be scrapped—a sad end she might have soon shared. (Courtesy of San Francisco National Maritime Historical Park.)

# Three

# "Things the World Cannot Afford to Lose"

*The sailing ship stood for a means whereby men were brought to their fullest development. She stood for a profession in which only merit could endure. She stood for real efficiency of spirit and character. She stood for things the world cannot afford to lose.*

—Lincoln Colcord

The *Elissa*'s age finally caught up with her. She had gone from being an aristocratic member of the British Merchant Service to a derelict former smuggler, with scrapping the only means left to generate income for her owners. Fortunately, the ship's amazing good luck saved her again. Underwater archaeologist Peter Throckmorton and museum director Karl Kortum had been keeping track of the vessel since the early 1960s. Using a cloak-and-dagger scheme worthy of a detective novel, they purchased the *Pioneer* (her most recent name) in November 1970 and began the long process of finding her a permanent home. One of their first acts, however, was to return her original name, the *Elissa*.

Kortum's San Francisco Maritime Museum was not in a position to take on another project, and his efforts fell through to find the ship a berth in Monterrey, California; Portland, Oregon; and Victoria, British Columbia. Even though the *Elissa* was of a manageable size (very small, actually, for a square-rigger), the task proved to be too daunting for those communities.

Finally, in 1975, Galveston, Texas, came to the rescue. The Galveston Historical Foundation, leaders of trailblazing historic preservation efforts in that city, purchased the ship to complement their efforts ashore.

Peter Throckmorton found the *Elissa* in 1961 while he was delivering a motor launch to Piraeus, Greece. In January 1969, South Street Seaport Museum's Peter Stanford put him in touch with Karl Kortum, who had been following the ship independently since 1964. Throckmorton (far left) is pictured aboard the *Elissa* during a 1984 day sail, his only opportunity to sail in the ship after she was restored. (Courtesy of Kraig Emmert.)

As part of the subterfuge necessary to hide the fact that an American museum was buying the ship (which would have quadrupled the price), Throckmorton mortgaged his schooner, the *Stormie Seas*, to raise the necessary cash. He wrote to Karl Kortum, urging that he be reimbursed as soon as possible: "My neck is in the noose for $13,500. If some idiot rammed *Elissa* tonight, I would lose my ship and the lot."

Karl Kortum (center in this 1963 photograph) is one of the unsung heroes of the *Elissa* story. While Throckmorton kept an eye on the ship in Greece (and received much of the press in later years), Kortum worked fervently to find the ship a real home. Without his involvement, the *Elissa* probably would have been scrapped in Greece. (Courtesy of San Francisco National Maritime Historical Park.)

In October 1970, Throckmorton cabled Kortum: "*Elissa* has been stripped by her owners, ready to sell for scrap. . . . She is a dismal sight there, doors hanging, some broken." Only someone with a trained eye would have suspected she had once been a proud sailing ship.

Throckmorton related to Kortum a tale about the smugglers who owned the *Elissa* (shown aboard the ship in 1968, at left) making the rounds on the Piraeus waterfront: "The gist of the story was that an English gunsel-type skipper-adventurer had been propositioned . . . by an English South African to take over an ex–Royal Navy minesweeper. He did so and was then offered a couple of thousand dollars if he would make a run with a cargo of cigarettes to a spot somewhere south of Bari. He accepted and the cigarettes were duly unloaded. . . . When they arrived off the Italian coast they were greeted with machine guns and the Italian Guardia Di Finanza. . . . The Guardia incarcerated the crew and towed the boat in. But the crunch was that meanwhile the *Elissa* people had quietly off-loaded 700 tons of cigarettes onto the beach 30 miles away. This, mind you, is not proven, but it gives an idea of how the boys operate."

This stern view of the *Elissa* was taken in April 1971, just five months after the ship was purchased by Kortum and Throckmorton.

While Kortum tried to find an organization capable of restoring the ship, Throckmorton continued to look after the vessel for the next five years. The *Elissa* is about to be hauled out for work below the waterline in this 1970s photograph.

When Peter Throckmorton first visited the captain's saloon in 1961, it would have looked much the same as this photograph made the following year. The builder's plate that he used to track down the history of the ship is the 1877 original, moved from the mizzenmast to an engine room ventilator. The entire saloon is little changed from the 19th century.

Below, the tile-lined fireplace would have originally housed a coal-burning stove or grate to provide heat. It appears to have been modified to hold rolled charts by the time this photograph was taken in the 1970s.

When a house covering the quarterdeck was built in 1936, the original 1877 teak companionway was left in place. Forward of the companionway is the original teak skylight (upper left, with vertical rails to protect the glass), atop which cabinets have been constructed. These structures were restored in the 1980s.

The ship's binnacle (which holds the compass) was moved from behind the companionway to the new steering station in the deckhouse. In all likelihood, this binnacle is the same one Henry Fowler Watt installed in Havre, France, in 1897 just before he sold the *Elissa*.

The *Elissa* was hauled in 1972 during the brief ownership of Canadian David Groos's Elissa Enterprises, Ltd. The removal of decades of old paint revealed her many paint schemes and the former names *Gustaf* and *Christophoros*.

She still looked like an Aegean smuggler when the Galveston Historical Foundation purchased the *Elissa* in October 1975. Few would have guessed that seven years later she would be an international standard of maritime preservation.

# Four

# "Queen City of the Gulf"

During the late 19th century, Galveston, Texas, was a marvelous combination of wealth, innovation, and urbane sophistication. Historian David McComb wrote: "The Island City was the most advanced . . . in Texas. . . . [It] was the most important port, it was the first to have telephones and electricity, it had the best newspapers and theater . . . the greatest variety of sports . . . the most individual wealth and the most advanced architecture, and it was a place of unique, sensual beauty which every visitor could feel." Local boosters called Galveston the "Queen City of the Gulf."

Ships of all kinds entered the busy port, the best deepwater harbor west of New Orleans. They left with cargo bound for ports around the world, especially cotton for the mills in England. The commerce generated along Galveston's waterfront created the wealth that made possible the impressive mansions on Broadway, the iron front buildings on the Strand ("the Wall Street of the Southwest"), and all the modern conveniences enjoyed by the city.

One of those ships was the British barque *Elissa*. She entered Galveston on December 26, 1883, with a load of bananas from Tampico, Mexico. After selling her shipment (aided by an advertisement in the *Galveston Daily News*), she loaded cotton and left for Liverpool on January 25. A few years later, on September 8, 1886, she returned to the bustling city, having sailed from Paysandu, Argentina. She remained in Galveston until September 20 and then headed for Pensacola, Florida. Galveston probably meant little to Henry Fowler Watt—just another port to sell his merchandise and pick up more, keeping the *Elissa* alive in the face of growing competition from steamships. A century later, the ship's survival would hinge on those two chance encounters with the city.

Once a stronghold for pirates and privateers, Galveston was the premier city of Texas by the 1880s. The Tremont Hotel, at upper left in this view looking north on Twenty-third Street, was the city's finest. Its guest list included Sam Houston, Ulysses S. Grant, and Buffalo Bill Cody. (Courtesy of the Galveston County Historical Museum.)

Ashton Villa (at left) was built in 1859 by business magnate James M. Brown. Its lavishness was the pacesetter for other mansions that would line Broadway in the late 19th century. In 1971, it was saved from demolition by the Galveston Historical Foundation, which operates it as a house museum. (Courtesy of the Galveston County Historical Museum.)

At the end of the 19th century, more cotton was shipped from Galveston than any other port in the United States. The *Elissa* carried cotton from Galveston to her home port of Liverpool in 1884. (Courtesy of Rosenberg Library, Galveston, Texas.)

Once known as "the Ellis Island of the West," more than 133,000 immigrants first entered the United States at Galveston. Some only passed through on their way to settlements west, but many others stayed, adding to the cultural diversity Galveston has always enjoyed. (Courtesy of Rosenberg Library, Galveston, Texas.)

Without its port—the best natural harbor west of New Orleans—Galveston would have been just another barrier island on the Texas coast. Grain elevators, railroads, ocean liners, steamships, fishing schooners, and excursion vessels can be seen in this view from the beginning of the 20th century. The basin at Pier 22 (in the center of this photograph) was once the home of the Gulf Fisheries Company. Today it is the berth of the restored *Elissa*. (Courtesy of the Galveston County Historical Museum.)

The Mallory Line was one of America's leading shipping companies. One of their ships, the *San Jacinto*, looms over the Pier 22 basin. The fishing schooner in the foreground, built in Essex, Massachusetts, is identical to those that fished the Grand Banks. (Courtesy of the Galveston County Historical Museum.)

The 1880 barque *Carrie Winslow*, a wooden "Downeaster" from Maine, was roughly the same size as the *Elissa*. Until miles-long jetties were completed in 1896, vessels such as the *Winslow* and the *Elissa* were the largest types of sailing ships that could cross the shallow bar at the entrance to the Galveston harbor. (Courtesy of the Galveston County Historical Museum.)

**Bananas For Sale.**
The British bark Elissa having just arrived from Tampico with a small cargo of choice Bananas, the same will be sold from the vessel at Labadie wharf this day in lots to suit the purchaser. Call early and secure a bargain.

The *Elissa* arrived in Galveston on December 26, 1883, with one passenger, R. W. Reed, and a load of bananas from Tampico, Mexico. A day later, this advertisement appeared in the *Galveston Daily News*. One of her crew jumped ship before she sailed for Liverpool with a cargo of cotton. She left on January 26 in the company of two other sailing ships also bound for Liverpool, the barque *Sheperton* and the brigantine *Alphonsine*. She arrived home in Liverpool on March 14.

The U.S. Life-Saving Service, a forerunner of the U.S. Coast Guard, maintained a station at San Luis Pass near the far western tip of Galveston Island. Built in 1879, its men walked the beach looking for vessels that ran aground after mistaking the shallow waters for the entrance to the harbor about 30 miles to the east. The brave crews were expected to launch their surfboats in any weather or sea condition to rescue stranded mariners. (Courtesy of Rosenberg Library, Galveston, Texas.)

A devastating hurricane destroyed much of Galveston on September 8, 1900. In terms of loss of life (experts believe that 6,000 to 8,000 people died), it remains the worst natural disaster in the history of the United States. Despite the wreckage along the waterfront, such as this schooner that was washed ashore, the port returned to some degree of operation by September 17.

*Five*

# A Tall Ship for Texas

Peter Brink, in the book *Maritime America*, provides an apt summary of the *Elissa*'s purchase and restoration by the Galveston Historical Foundation: "Thank heavens for dreams and blissful ignorance!" Some would add, "Thank heavens for the last great Texas oil boom." The eventual success of the *Elissa* project was made possible by of a unique convergence of circumstances: the right people were available to the right organization at a time when funds could be raised to cover the ever-soaring expenses. Such favorable conditions never existed before, and they have not occurred since.

After sending a team to Greece to make the hull sound and restore the clipper bow, the *Elissa* still looked like an Aegean smuggler—and a million dollars had been spent. When she finally arrived in Galveston in July 1979, the welcoming ceremonies were unofficially dubbed "the Emperor's New Clothes." Instead of acres of canvas, supporters saw an attractive hull that still needed its ugly deckhouse removed and decks scrapped before a proper restoration could begin.

Many people in Galveston were disheartened. David Brink, Peter's brother, was hired to evaluate the project and provide ideas for moving forward. David, who had experience with sailing ships, education, and nonprofit management—a rare combination of talents—first recommended that the foundation cut its losses and abandon the project. Four times the original estimate had already been spent, and the lion's share of the work remained to be done. The board of directors made it known that abandonment was not an option.

Instead, David Brink was asked to become project director. With restoration director Walter Rybka and project administrator Michael Cochran, the three project leaders developed a plan to finish the job. The objective shifted from a ship that would spend most of its time at sea, to a museum ship capable of sailing on a limited basis, as funds allowed. The ultimate objective, however, remained: the quality and accuracy of the restoration must set new standards for maritime preservation. After a two-year do-or-die effort, those lofty goals were achieved when the *Elissa* opened to the public on July 4, 1982.

Not long after the Galveston Historical Foundation purchased the *Elissa* on October 2, 1975, the proud new owners received word the ship had sunk at her mooring in Piraeus, Greece. It turned out that a rivet had merely come loose, and she was soon refloated. Michael Creamer, the ship's first project director, wrote: "I resolved that it was *Elissa* calling for help."

Work began in July 1977 when a restoration crew arrived in Piraeus. The crew was led by Creamer and restoration director Walter Rybka. The first order of business was to remove decades of rust and detritus that had accumulated aboard the ship, all of which had to be loaded into a small boat and rowed ashore.

After the *Elissa* was hauled out on October 6, 1977, the team discovered that earlier surveys were too optimistic about the condition of the hull. A laborious process of gauging the thickness of all the shell plates (as Rybka is doing here) revealed that 25 percent of them would have to be replaced before the ship could safely return to Galveston.

Local contractor Nick Pagamenos (below, at left, speaking to Michael Creamer) was instrumental in dealing with the Greek shipyard. According to Walter Rybka, "It was assumed all along the waterfront that we could afford any price . . . it was also assumed we were idiots." Pagamenos helped negotiate a contract that reflected the project's financial realities.

Replacing riveted iron hull plates with new ones of welded steel posed many challenges because of the different characteristics of the two metals. For example, to distribute stress properly, more than just the corroded part had to be cut away. Since no one had attempted such repairs before (certainly not on such a large scale), Rybka and the restoration team developed pioneering new procedures.

Wrought-iron hulls are intolerant of poorly fitted new sections. Each new welded steel plate had to match exactly right, and every weld had to be perfect. The process required skill as well as time and money.

As a shipfitter prepares a new steel plate, Nick Pagamenos strides through the hull, monitoring the work and making sure it meets required standards.

Before many of the hull repairs could be made, four people spent four months chipping away the cement liner that covered two-thirds of the hull, which had never been removed since being poured in 1877.

53

Michael Creamer and Walter Rybka made the wise decision that all work done by the shipyard had to be approved by a surveyor from Lloyd's Register, the famous maritime classification society. Surveyors such as Brian Pearson (center, consulting with Creamer, left, and Rybka, right) were an invaluable source of advice and served as the final arbiter in any disputes.

Galveston restaurateur Paul Gaido (kneeling, facing the camera) was instrumental in implementing his dream of a sailing ship for Galveston's historic waterfront. With enthusiasm as their primary resource, he and the *Elissa* Committee raised $450,000 to help pay for the "Greek Campaign." Gaido is shown here at the 1974 purchase survey of the ship.

Fifty tons of steel (donated by the Armco Steel Company) were used to replace hull plates and frames while the ship was in Greece. In the midst of this process, another crucial event took place. On March 21, 1978, the *Elissa* was listed on the National Register of Historic Places, the first time a historic structure outside the United States received this designation.

By the 1970s, little remained of the *Elissa*'s 1877 grandeur. One notable exception was the officers' accommodations located at the rear of the ship. Each piece of paneling was numbered, carefully removed, and then meticulously re-created later in the restoration.

The most noticeable transformation during the "Greek Campaign" was the return of the *Elissa*'s distinctive bow. The Alexander Hall and Company developed the Aberdeen bow, better known as a clipper bow, which first appeared on the *Scottish Maid* in 1839.

The restoration crew agonized over getting every detail of the new bow just right. It was first mocked up using wooden forms and then viewed from every available angle. After three days of looking at it from near and far, approval was finally given for fabrication.

Designing the correct profile was only part of the challenge of re-creating the clipper bow. The transverse (side-to-side) sections were just as critical and had to be faired into the existing hull. The skill required for such precise work characterized the entire restoration.

Restoration of the distinctive sailing ship bow let everyone know that the *Elissa* was different from her sisters. Walter Rybka wrote that the normally jaded shipyard workers "perceived that *Elissa* was a very special lady and took great pride in doing their very best on this particular job."

Hull repairs were nearly complete when this photograph was made not long before the ship was refloated on May 12, 1978. Seventy tons of ballast and 150 tons of "build-a-barque kit"—myriad supplies necessary for the ship's further restoration—had to be carefully stowed before the *Elissa* could leave Piraeus. With disenchantment rapidly growing in Galveston, supporters believed it was imperative that the ship return home to raise desperately needed funds.

After nearly 20 years in Greece, the *Elissa* left Piraeus on December 12, 1978, towed by the Italian tug *Mare Ionio*. She arrived in Gibraltar a week later, on December 20. The Royal Navy provided a safe winter berth while negotiations and fund-raising proceeded to bring her the rest of the way home. Signs of her brush with heavy weather during the Mediterranean passage can be seen in this photograph, taken at Gibraltar in January 1979.

Michael Creamer remained in Gibraltar as ship keeper while the rest of the crew returned to Galveston. For months, he tried to secure a donated or discounted tow but to no avail. Ultimately, funds were borrowed to pay for the tow. Arrangements were made with Zodiac Offshore, Inc., owners of the huge oceangoing tug *Polar 901*, which was bound for Houston from the Persian Gulf.

On June 25, 1979, the *Elissa* finally left Gibraltar for Galveston with no stops in between. Normally assigned to bring in supertankers with mechanical problems, the *Polar 901* towered over the little *Elissa*. Walter Rybka often said, "The procession rather resembled a fat man with a toy poodle on a leash."

The *Elissa* arrived in Galveston on July 20, 1979, quietly, so the crew could make her presentable for a public debut on August 4. With flags flying and bands playing, the speeches that day encouraged everyone to look beyond the rotting decks and imagine what the ship would become. Harsh realities had to be overcome first: the project was $300,000 in debt, grossly over budget, and the resources of the Galveston Historical Foundation were already spread thin on projects onshore.

Despite daunting challenges, the ship's supporters persevered. Thanks to *Elissa* devotee Harry Brown, the Duval Sulphur Company provided a slip far away from the public eye while the project regrouped. Work resumed in early 1980 under a new management team led by project director David Brink, restoration director Walter Rybka, and project administrator Michael Cochran.

Before further restoration could begin, all the gear brought from Greece had to be unloaded, the aft deckhouse demolished, and the old decks removed. The ship was completely taken down to a bare hull.

The companionway to the officers' quarters was one of the few 1877 pieces still aboard the *Elissa*. It was moved to a donated warehouse on Mechanic Street in the Strand Historic District and carefully restored.

Two grants from Galveston's Moody Foundation, totaling $1 million and made at critical junctures, allowed the *Elissa* restoration to continue. The second grant of $750,000 came in early 1980 after Mary Moody Northen, the family's matriarch, went for a day sail off Galveston in the Norwegian sail-training vessel *Christian Radich*. Mary Moody Northen stands in front of a painting of the *Elissa* by prominent marine artist John Stobart. Today the painting hangs in the board room of the Moody Foundation.

Michael Creamer built this model of the *Elissa* soon after the ship arrived in Galveston. At that time, it took great imagination to picture the *Elissa* as a proud sailing ship. The model served as a fund-raising and motivational tool.

The *Elissa* entered Galveston's Todd Shipyard in the fall of 1980 to replace bulwarks, hatch coamings, and steel structures necessary to support the deck. During this process, Rybka learned that modern shipyard workers had a difficult time with *Elissa*'s complex shapes. For the remainder of the restoration, the Galveston Historical Foundation essentially created a shipyard on-site and then hired the best craftsman from across the country.

These were the opulent facilities enjoyed by the staff and volunteers during the two years the *Elissa* was berthed at the Duval Sulphur docks. The author remembers carefully checking for rattlesnakes whenever searching through the piles of materials. This photograph was taken in the late fall of 1980.

Steel work, such as riveting the bulwarks to the sheer strake, was one of the skilled tasks taken on in-house. Don Birkholz (right), who started as a volunteer in Piraeus, joined the staff as supervisor of the steel team.

Any drawings that may have existed of the *Elissa* were destroyed when the Alexander Hall and Company was bombed during World War II. Obsessed that every detail be correct, the staff poured over hundreds of photographs of ships of the era, especially Hall-built barques. Information from the *Quathlamba*, pictured here, was particularly useful. She was built in 1879, just six hull numbers after the *Elissa* (294 versus 300) and was roughly the same size. (Courtesy of the State Library of Victoria.)

Volunteers were always an important part of the *Elissa* project, but they were not formally organized until the fall of 1980. Jim Story (left) and his wife, Annette, established the program that became a national standard. The first volunteer orientation was held on October 25, 1980.

By February 1981, the new deck was being laid. The carpentry crew started in the officers' accommodations since it was not a weather deck and any learning mistakes would have fewer repercussions. After planks were bolted to the deck beams, cotton and oakum (loose jute fibers saturated with pine tar) were driven into the seams and then covered with melted pitch to make them watertight. The workers in the photograph below are using a horsing iron and a special mallet to carefully caulk the deck. If the cotton and oakum are too loose, the deck will leak and soon rot. If driven too tightly, the seam between the planks might be ruined, also causing leaks. This painstaking procedure had to be followed for every inch of every deck seam.

Satisfied that the procedures developed met the project's high standards, the deck caulkers moved to the main deck. This is how the *Elissa* appeared in the spring of 1981.

Restoration director Walter Rybka (left) and chief carpenter Ed Claxton (right) scrutinize a sample stanchion for the break of quarterdeck rail. Several styles and dimensions were made of Douglas fir before the final versions were turned from teak. Such attention to detail was standard operating procedure.

The *Elissa* started to look like a sailing ship again when the first spars were stepped in the summer of 1981. The bowsprit went in first, in June, followed by the lower foremast on July 11. The bowsprit and the lower masts on the fore and the main are made of steel (they were originally riveted iron). All of the other spars are Douglas fir.

A different coin is beneath each of the *Elissa*'s three masts: the fore has an 1877 British gold sovereign (which appears in the photograph), an 1883 silver dollar is under the main, and below the mizzen are a 1978 Greek 20 drachma piece and a 2004 Texas quarter. This ancient superstition comes from Greek mythology: in the event of a mishap, a coin under the mast would pay Charon to row the crew across the river Styx.

The *Elissa* was towed to Houston for dry-docking in August 1981. In addition to scraping and painting the bottom, the rebuilt rudder was installed as well.

Shortly after the ship returned from her August dry-docking, the lower mainmast was stepped (shown here), followed by the lower mizzen a few weeks later. (Courtesy of Kurt Voss.)

A forge was set up on the dock, and Doug McLean (left) became the ship's blacksmith. After a short apprenticeship with Joe Pehoski of Salado, Texas, McLean made many of the custom fittings required for the ship.

One of the last jobs done at the Duval Sulphur docks was raising the fore and main topmasts. Chief rigger Steve Hyman (below) and assistant chief rigger Eric Speth (above) are attaching standing rigging that supports the masts.

After months of preparation, the *Elissa* moved to her new berth at Pier 21 in November 1981. The site had once been home to the sleek schooners of the Gulf Fisheries Company, but in recent years, it had become a dumping ground. Much debris had to be removed from the slip, bulkheads and piers were added or rebuilt, and what was left of an early-20th-century shed was renovated as a workshop.

The best artisans from across the country gravitated to the *Elissa* project. Word spread in the historic ship community of the high quality of work being done, and people wanted to be a part of it. Carpenters Rinn Wright (at right) and Rick Waters (below) are shaping the teak pin rails with hand tools, exactly the way it was done in 1877.

While work was progressing aboard the ship, riggers and carpenters prepared the masts, yards, and standing rigging in a donated warehouse on Mechanic Street, one block from the Strand. The spars were rough turned at a lumber mill in Oregon, then reduced to precise dimensions after their arrival in Galveston. When finished, they were carried three blocks to the ship. Two miles of standing rigging to support the masts also had to be fabricated. Each piece of steel cable was spliced, a heavy twine called marline was laid in the grooves, then wrapped tightly in pine tar-soaked burlap. Finally, marline was tightly wound around the entire length. Riggers worked on this task for more than a year.

As the rig went up, ballast had to be loaded to counteract its weight to prevent the *Elissa* from turning over on her side. Two hundred and fifty tons of large concrete blocks, supplemented by barrels filled with pig iron and concrete, were placed aboard the ship. In 1990–1991, a steel trunk filled with dense steel bars replaced this ballast system.

By early January 1982, topgallant masts had been sent up on the fore and the main, the mizzen topmast raised, and the jibboom run out. Much worked remained to be done before the *Elissa*'s public opening, scheduled for July 4 of that year.

The deckhouse originally contained the galley, a steam "donkey" engine (used to assist in handling cargo), and bunks for the cook and carpenter. Once again, no shortcuts were taken; traditional constructions methods were used throughout.

Eli Kuslansky, a sculptor from New York and one of the Piraeus volunteers, was hired to carve the ship's figurehead. As a tribute to the generous support of the Moody Foundation, the face of the sculpture was styled in the likeness of a young Mary Moody Northen. Amy McAllister, part-time *Elissa* rigger and a student at Texas A&M Maritime Academy, was a life model for the rest of the figure. McAllister sailed as a mate in large merchant ships after her graduation from the academy.

International wire services picked up this photograph of Amy McAllister and broadcast it around the world. Sculptor Eli Kuslansky needed a live model to determine the figurehead's proper angle to the bow.

At the height of the restoration in the late spring and early summer of 1982, sixty paid staff worked during the week, assisted by 35 to 50 volunteers each weekend. The staff supervisors worked for months with no days off to keep the project going. One of the few respites from the long hours was rowing and sailing the *Boondoggle*, a former lifeboat purchased in Greece.

Cranes were used to set the three lower masts, but all the other spars were installed using blocks, tackles, and human muscle. The *Elissa*'s fore and main masts have three sections: lower mast, topmast, and topgallant mast. The mizzen has only two parts, the lower and topmast. An upper topsail yard is being crossed in this photograph from May 1982.

The Fourth of July grand-opening celebrations were looming on the horizon when this photograph was taken in June 1982. The crew worked around the clock during those last few weeks to meet the deadline.

Nat Wilson of East Boothbay, Maine, made the *Elissa*'s suit of 19 sails. Wilson and several of his workers arrived in Galveston in late June 1982 to help bend on the 12,000 square feet of Duradon synthetic canvas. Staff and volunteers have just furled the mainsail, the first of the sails to go up. For the first time since the early 1920s, the *Elissa* once again carried a square sail.

Except for the modern shipyard in the background, one almost expected to see Henry Fowler Watt come up the aft companionway on the morning of the ship's public unveiling. The deck furniture has been restored, the wheel box accurately recreated, and the running rigging is ready for handling sails. (Courtesy of Kurt Voss.)

With sails bent to the royals and as many set as the wind would allow, the *Elissa* greeted her public on July 4, 1982. It was an indescribable moment, one that many experts said would never happen. (Courtesy of Kurt Voss.)

Joy and relief are apparent in this photograph of the three men most responsible for the *Elissa*'s unprecedented resurrection. The talents of Michael Cochran, David Brink, and Walter Rybka (pictured here from left to right) complemented each other perfectly. The teamwork they exhibited was essential to the project's success. (Courtesy of Kurt Voss.)

81

Although some restoration work remained to be done, "the ship [was] now real and beautiful," Walter Rybka wrote. With such an important milestone met, everyone's attention turned to training a crew and getting the ship underway. (Courtesy of Kurt Voss.)

## Six

# The *Elissa* Sails!

Three years of restoration work had been compressed into two—an amazing feat. Walter Rybka wrote in *Sea History* magazine:

> Part of the reason it worked is that our people looked at the ship as an artistic expression, an opportunity to create something lasting and worthwhile. . . . The ship has a special feeling about her because she is the repository of so many people's honest best efforts. The spirit of the ship is a part of everyone's soul who has cared for her and in turn drawn strength from her.

Many jobs remained to be done, such as joiner work in the officers' accommodations and construction of the forward deck lockers, but those tasks were secondary. Everyone's attention turned to sailing the ship at the end of August 1982—less than two months away. Funding priorities required that the large paid staff be reduced to a maintenance level, drastically reducing the available pool of labor. The volunteer corps, which had been an adjunct to the restoration, became even more important.

At the top of the to-do list was training a crew, many of whom had never sailed before, much less crewed a three-masted square-rigger. One more time, everyone pulled together (literally and figuratively) to make sure the ship and her people were ready for four day sails during the 1982 Labor Day weekend.

The success of the first series of day sails led to more ambitious journeys away from Galveston. The *Elissa* travelled to Corpus Christi, Texas, in the fall of 1985, and to Gulfport, Mississippi, in 1987. The crowning achievement, however, was the ship's 1986 voyage to New York to take part in the rededication of the Statue of Liberty. Thanks to widespread attention from the national media, the *Elissa* captured the imagination of people all over America.

The *Elissa*'s running rigging is 2.5 miles long and includes 183 separate lines. The inexperienced crew had to know the names and location of each one before learning how to use them. (Courtesy of Kraig Emmert.)

Nineteenth-century sailing ships used very few mechanical aids, relying instead on the human power of the crew. Setting, dousing, furling, and trimming the sails required pulling on lines. It still does.

A device that provides a little mechanical relief for the crew is the capstan on the main deck. A smaller one is on the fo'c's'le head at the front of the ship. They are used to handle the lines with the heaviest loads. (Courtesy of Kraig Emmert.)

Dockside training sessions taught the crew knots, how to set and furl the sails, and basic commands. One volunteer commented that the experience was similar to learning a foreign language. (Courtesy of Kraig Emmert.)

Capt. Carl Bowman, master of the U.S. Coast Guard barque *Eagle* from 1950 to 1954, was the *Elissa*'s captain for the 1982 sea trials. Paul Seiler, Captain Bowman's bosun on the *Eagle*, was chief mate. The other mates were Walter Rybka and Joe Braun, who had served as second mate on the large German sailing ship *Passat* during the late 1950s. Braun's experience was particularly useful when he assisted Walter Rybka with the dockside training classes.

The training was intense and often lasted until well past dark. With so much at stake, the crew had to be proficient. Walter Rybka remarked: "*Elissa* had no engine, only a handful of professionals, and the decks were to be filled with guests that would outnumber the crew two to one." (Courtesy of Kraig Emmert.)

After a month of grueling training and seemingly endless tasks to get the ship ready, the day everyone had waited for so long finally arrived. Mooring lines have been singled up and slack in the towing hawser is being taken up in this photograph, made just as the ship was getting underway.

Folksinger "Ramblin' Jack" Elliott, a protégé of Woody Guthrie, worked as a rigger in the final months of the *Elissa* restoration. As the ship left Pier 21 for the shakedown sail, Elliot was still aloft, attending to a task at the main crosstrees. A number of the crew had worked into the wee hours of the morning doing similar last-minute jobs.

The *Elissa* sailed for four years without an engine. She was towed from her berth at Pier 21, down the channel, and beyond the Galveston jetties, which took about an hour. After setting sail, the towline was cast free, and she proceeded under wind power alone.

"Miracle" and "dream" were two words in the minds of many people when the *Elissa* finally sailed on August 31, 1982. The officers and crew soon discovered that her sailing qualities matched her beauty.

Chief rigger Steve Hyman was finally able to handle sails in the rig he had helped design and build. Hyman, who came to the *Elissa* project from the San Francisco Maritime Museum, was one of the experienced professionals in the crew that first year.

Three more day sails on September 2, 4, and 6 followed the August 31 shakedown. A lay day was scheduled between each sail so that inevitable adjustments and corrections could be made. Riggers have just finished taking the slack from a shroud that supports one of the masts. Kurt Voss is completing that process by putting a seizing on a lanyard.

89

Volunteers and a drastically reduced staff settled into never-ending maintenance chores after the 1982 day sail series. Restoration work continued, too, such as completion of the officers' accommodations and the construction of two wooden deck structures forward. The fall of 1983 brought another round of successful day sails.

The *Elissa*'s extraordinary good luck held in May 1984 when a huge floating drydock broke its moorings in a thunderstorm and drifted down on the ship. Although the *Elissa*'s stern was crumpled, the situation could have been much worse. Steel hurricane pilings installed the summer before stopped the drydock and prevented further damage. Construction of the elaborate hurricane mooring system was finished days before Hurricane Alicia hit in August 1983. The ship suffered only a broken belaying pin from the category 3 storm.

Damage to the stern was extensive. "Plates torn and buckled, counter upset, rudder trunk displaced, deck beams tripped, and stringer buckled," Walter Rybka reported. Plans for repairs were complicated by the stern's complex shape and the original 1877 hull structure. The landmark restoration could not be compromised by imperfect methods.

Repairs were made mostly in-house since many of the skilled people who had recently rebuilt the ship were still available. Mending the rudder was the only job that required dry-docking and shipyard work.

The crew worked around the clock to finish the job in time for the 1984 sea trials. The repairs were finished just in time: the crew was still attaching the spanker, the large sail on the mizzenmast, as the *Elissa* headed down the channel for the 1984 shakedown day sail. Don Birkholz Jr., steelwork supervisor during the ship's renovation, rivets new hull plates in the dark.

In 1985, a replica was built of one of the three small boats the *Elissa* would have carried, thanks to a joint project between Galveston Historical Foundation and the Apprenticeshop in Rockport, Maine. Mike Mefferd, a recent graduate of the famous boatbuilding school, led the effort. He was assisted by volunteers who welcomed the chance to learn traditional small-boat construction methods from a professional. The new boat, named simply the *Elissa 3*, was finished just in time to be one of the highlights of a maritime art exhibition at the Galveston Arts Center.

The happy outcome of the *Elissa 3* project led to two more small craft in 1986. Mike Mefferd took charge of the construction of one of the boats, while volunteers built a duplicate under his guidance. The two skiffs were accurate replicas of a 1915 pleasure boat owned by John Eggert, whose company raised many of Galveston's large buildings after the 1900 storm. The boats were named the *Flim-Flam* and the *Filibuster*. One is still used at the museum; the other was lost in Hurricane Ike. (Both, courtesy of Kraig Emmert.)

The saloon was the captain's office at sea and in port. The table at lower right would have been used for navigation while underway and for entertaining when the captain had guests from shore aboard. Forward of the saloon are the first and second mates' cabins, the pantry, and a space for the bosun's supplies. One or two apprentices (teenaged boys training to be officers) were also berthed in this area.

The *Elissa*'s first offshore trip after her restoration came in November 1985. The Art Museum of South Texas brought the ship to Corpus Christi as part of their "Art and the Sea" fund-raising gala. The voyage generated much-needed funds for the ship and paved the way for the *Elissa*'s participation in OpSail 1986 the following year.

The story of the *Elissa*'s 1986 voyage to participate in the rededication of the Statue of Liberty is worthy of its own book. It was a trip fraught with controversy and perseverance. The *Elissa* left Galveston on Memorial Day 1986 and made port visits in Miami, Florida; Charleston, South Carolina; Annapolis and Baltimore, Maryland; Washington, D.C., and Norfolk, Virginia. She sailed past the twin towers of the World Trade Center shortly after her arrival in New York on July 2.

Although many people worked hard to make the New York voyage happen, the driving force behind it all was the vision and persistence of David Brink. He overcame many doubts and objections as he raised $800,000 for the costs of the trip—in the face of a collapsing oil economy. Those expenses included the installation of an engine, a complete engine room, and a watertight bulkhead. It must have been a sublime moment for David Brink as he steered past the Manhattan skyline.

Except for the night of July 3, the *Elissa* was berthed at New York's South Street Seaport Museum. Many of the ship's restoration crew were alumni of South Street: David Brink, David Canright, Steven Canright, Michael Creamer, Jack Elliot, Richard Fewtrell, Eli Kuslansky, Walter Rybka, and Peter Stanford.

The *Elissa* was one of the last of 23 ships to arrive in the anchorage off Sandy Hook on July 3. Walter Rybka wrote in *Nautical Quarterly*: "She swept in with a bone in her teeth, and in the span of about three minutes sails came down by the run, the wheel spun while the yards braced square to throw her aback as she came up to the wind . . . followed by . . . the rumble of the [anchor] cable." (Courtesy of Kurt Voss.)

OpSail 1986 brought the *Elissa* and the Galveston Historical Foundation into the national spotlight. The *Elissa* captured the imagination of the media everywhere she went, especially the wire services and network news programs. Unlike most of the other tall ships at the Fourth of July celebration, the *Elissa* was not government sponsored, sailed by a crew of cadets. She belonged to a visionary nonprofit organization and was crewed largely by volunteers. Everyone involved had accomplished the impossible. Many believed it could have happened only in Texas.

On the return trip to Galveston, the *Elissa* visited New Haven and Bridgeport, Connecticut; Bermuda; and Miami, Florida. One of the highlights of the voyage home, however, was her stay at Connecticut's Mystic Seaport Museum, a mecca for most traditional maritime enthusiasts. The *Elissa* lies just to the left of the 1841 whaling ship *Charles W. Morgan*.

Accommodations on the New York trip were primitive. With only 14 permanent bunks on board, most of the 40-plus crew slept on cots lashed to the rails of the exhibit deck. This space was affectionately known as "Camp *Elissa*." (Courtesy of Kraig Emmert.)

A squall caught the *Elissa* as she approached Bermuda and cracked her jibboom, the long wooden spar at the bow of the ship. This photograph was taken at sea as the broken jibboom was being cleared away. Since only the outer section was wrecked, it was carved down, and the ship returned to Galveston minus the outer jib.

The *Elissa* made a triumphant return home on August 2, 1986. She was greeted by a fleet of escort vessels and hundreds of well-wishers at her Pier 21 berth. The cut-down jibboom is clearly visible in this photograph.

The *Elissa* project did not bask in the success of the New York voyage for long. The unprecedented publicity brought an enormous increase in attendance, which helped fuel new projects and keep existing ones going. Almost immediately, the crew began preparations for the fall day sail series. Walter Rybka, now a consultant to the project, led efforts to comply with extensive U.S. Coast Guard regulations, which came into force when the engine was added. He was also responsible for training 130 new volunteers, a task made more difficult by losing many of the experienced crew who had to return to jobs and families. (Left, courtesy of Kraig Emmert.)

The *Elissa* is charging along with a bone in her teeth under the watchful eyes of her figurehead.

David Brink left the Galveston Historical Foundation after the New York trip to pursue his idea of building a new sail-training ship similar to the *Elissa*. A year later, his new company, Sea Adventures in Learning, Inc., chartered the ship for visits to Beaumont, Texas, and Biloxi, Mississippi.

Volunteer Kirsten Miles climbs aloft to loose sail. Working in the *Elissa*'s rig requires a cool head and a steady hand.

Even day sails within sight of Galveston can bring tense moments that call for able seamanship. The crew are hurrying to furl the headsails before an approaching squall reaches the ship. (Courtesy of Kraig Emmert.)

This small galley feeds as many as 120 people. The wood-burning Shipmate stove in the foreground was the only means of cooking from 1982 to 1986, when Karen Lord Wright prepared this meal. An electric range was added for the trip to New York.

Much of the maintenance work done by the volunteer crew is hot, filthy, and sometimes dangerous. The *Elissa*'s 2.5 miles of standing rigging must be slathered with pine tar at frequent intervals, as Jane Avila is doing here. (Courtesy of Kraig Emmert.)

# Seven

# Keeping the Dream Alive

Ambitious ventures have long been a hallmark of the Galveston Historical Foundation. The organization embarked on another one in the late 1980s when it decided to expand the *Elissa* project and become the Texas Seaport Museum. An increased presence ashore would allow better interpretation of Galveston's role in the maritime history of Texas and provide proper facilities for education programs and a growing staff. The aim was to broaden the mission—and its public appeal—beyond what could be accomplished with the ship alone.

While the site was being prepared and the workshop rebuilt, the *Elissa* left Galveston for the Texas Proud tour. During the spring of 1989, she was greeted by huge crowds at 10 ports between Brownsville, Texas, and Pensacola, Florida. The trip kept the ship in the public eye and softened the financial blow from a large drop in attendance during the worst of the construction upheaval.

Gradual growth while strengthening programs characterized the Texas Seaport Museum after its October 1991 opening. In the late 1990s, an award-winning youth sail-training program was added to adult seamanship training (which is still a national standard). Acquisition of the 48-foot modern vessel *Seagull II* in 2002 allowed new waterborne education programs to be conducted daily. The *Santa Maria*, a 45-foot wooden shrimp boat built in 1937, joined the fleet the following year. And the *Elissa* continued to venture away from Galveston. She travelled to Baton Rouge and New Orleans, Louisiana, in 1996 and made a triumphant return to Port Aransas and Corpus Christi, Texas, in 2007.

Hurricane Ike struck Galveston on September 13, 2008, and sorely tested the mettle of the Texas Seaport Museum's staff and volunteers. The *Elissa* received only minor damage, but the workshop—so necessary to the support of the ship—was a chaotic mess after a 12-foot storm surge. The museum, theater, and gift shop in the Jones Building were flooded, too, requiring extensive repairs. With so much to overcome, many believed the annual spring sea trials would have to be canceled. The pundits should have known better. On March 20, 2009, the *Elissa* slipped her lines and went sailing in the Gulf of Mexico—right on schedule.

The 1989 Texas Proud tour continued the *Elissa*'s tradition of voyaging offshore. During the three-month-long trip, she traveled to Houston, Beaumont, Freeport, Palacios, Corpus Christi, and Brownsville, Texas, followed by port visits at Baton Rouge, Louisiana; Gulfport, Mississippi; Pensacola, Florida; and New Orleans, Louisiana.

A large crowd in Pensacola, Florida, is ready to welcome the *Elissa* as a crew member casts a heaving line ashore. The ship received the same enthusiastic reception at each of the 10 ports on the Texas Proud tour.

The *Elissa* sailed back to Galveston at the beginning of the 1989 tourist season. By that time, overhaul of the piers and workshop had been completed, allowing always-needed income to be generated from public visits while the rest of the site was being finished. (Courtesy of Jeff DeBevec.)

The new structure that housed the museum, theater, gift shop, offices, and library was named the Jesse H. Jones Building in honor of the Houston politician and philanthropist. The gala opening of the Texas Seaport Museum was on October 26, 1991.

The displays in the new museum were designed by Vincent Ciulla Design of New York, one of the nation's leading exhibit planners. A multimedia presentation about the *Elissa*'s history and restoration was shown in the theater. Upstairs, computer terminals allowed visitors to access an immigration database with the names of everyone who had first arrived in Galveston from a foreign country.

Capt. Richard "Kip" Files has been an *Elissa* officer for two decades; nearly half of that time has been spent as her primary captain. He is the owner and captain of his own vessel, the 135-foot, three-masted schooner *Victory Chimes*, built in 1900. (Courtesy of Phil Niewald.)

Children's education programs have always been a key component of the *Elissa*. In the late 1990s, youth seamanship training was added to the curriculum of school tours and children's overnight program (the latter gives young people a taste of what it was like to be a sailor in the late 19th century). Youth sail training parallels the adult course. Participants must attend a certain number of sessions and pass a series of tests before sailing alongside their adult mentors as full-fledged crew members on an *Elissa* day sail.

Most museum vessels are dead ships; they never leave the dock. Without a large crew to maintain them and the regular inspections required by the U.S. Coast Guard, too many fall into disrepair. Because she sails, the *Elissa* is alive. Learning to sail and maintain the ship is the primary motivation of the large corps of volunteers, most of who would not be there if the ship were a static display. They consistently donate more than 20,000 hours per year to keep the *Elissa* sailing. (Courtesy of Jeff DeBevec.)

The *Elissa* ran into a gale on her way to New Orleans in March 1996. The wind blew at over 40 miles per hour for nearly a full day. It was the most wind and the highest seas the ship had seen in quite some time. (Courtesy of Charles Volek.)

This photograph was taken from a passing oil field supply vessel on March 27, 2001, as the *Elissa* was leaving Galveston for an overnight sail in the Gulf of Mexico. After taking three waves over the bow while still inside the jetties, Capt. Richard Files, not wanting to risk injury to the ship or crew, turned the *Elissa* around and anchored until the next morning.

115

The installation of an engine in 1986 allows the *Elissa* to safely and more easily sail from the channel-side pier at the Texas Seaport Museum. Before that, from 1982 to 1985, the ship usually anchored out after each day sail. Day sail guests were shuttled to and from the ship on the oil field crew boat *Miss Roseann*. (Courtesy of Dagon James and Rebecca Hall.)

For a decade, each annual day sail series has culminated in an overnight sail with just the officers and volunteer crew aboard. Unlike a day sail, when all 40 of the crew work at the same time, the crew is split into three watches. Their goal is to handle the ship with only the watch on deck—about a dozen people. (Courtesy of Phil Niewald.)

The suction created by an overtaking tanker swept the *Elissa* into its stern as both ships proceeded up the Houston ship channel in March 2002. Thankfully, damage was confined to a broken jibboom (for the third time) and minor rigging failures.

Wooden shrimp boats have all but disappeared from the upper Texas coast. One exceptional example became part of the Texas Seaport Museum in July 2003 thanks to the efforts of Galveston Historical Foundation executive director Marsh Davis and generous donors. J. D. Covacevich built the shrimper in 1937 as the *Miss Galveston* in Biloxi, Mississippi, for the Grasso Seafood interests. Joe Grillo bought the boat in 1951 and earned his living with her until she was acquired by the Galveston Historical Foundation. Pictured from left to right are Marsh Davis, executive director of the Galveston Historical Foundation; Kurt Voss, director of the Texas Seaport Museum; and John Moran, a volunteer. (Courtesy of Charles Volek.)

U.S. Coast Guard regulations require that the *Elissa* be dry-docked twice every five years. In addition to new bottom paint, the ship receives numerous inspections of the hull, machinery, and gear that can only be accessed while she is out of the water. The cost of a routine dry-docking is in the neighborhood of $100,000. (Courtesy of Phil Niewald.)

The cost and complexity of maintaining the *Elissa* grows with each passing year. The ship received a new lower mizzenmast in 2005, the first major spar to be replaced since completion of the restoration (other than damage repairs). It was stored for three years while the green lumber became dry enough to be shaped. (Courtesy of Kurt Voss.)

The *Elissa* escorted the brand new USS *Texas* into Galveston for its commissioning ceremonies in September 2006. First Lady Laura Bush was the submarine's sponsor. (Courtesy of John Moran.)

In October 2007, the *Elissa* travelled to Port Aransas and Corpus Christi, Texas, as a participant in the Harvest Moon Regatta. The trip was underwritten by Houston's Lakewood Yacht Club, sponsors of the offshore sailboat race, which usually has 200 entrants. The *Elissa* won the 1877 Cruising Division, a tongue-in-cheek category created for the historic ship. (Courtesy of Greg Branan.)

Years of planning and preparation paid off when Hurricane Ike struck Galveston on September 13, 2008. The 12-foot storm surge, driven by wind at the threshold of a category 3 hurricane, flooded the Jones Building and did extensive damage to the workshop and wooden piers. A storm-mooring system developed by Walter Rybka in 1983 and an elaborate hurricane plan implemented by the volunteers and staff ensured that damage to the *Elissa* was relatively minor. She lost the fore lower topsail, and the teak rail on the stern was damaged. (Above, courtesy of Dennis Dornfest; below, courtesy of Beth Karna.)

Water in the workshop reached a height of about 6 feet. The ship's *Elissa 3*, placed inside the shop before the storm, came through with minor scrapes. Two other small boats moored next to the *Elissa* also fared well, but one skiff was lost, as was a World War II lifeboat. (Courtesy of John Schaumburg.)

This shrimp boat, docked at the Mosquito Fleet basin two blocks away, fetched up just outside the entrance to the Texas Seaport Museum. The museum's own shrimp boat, the *Santa Maria*, suffered only moderate damage when her pier collapsed. (Courtesy of Kurt Voss.)

On June 8, 2005, Gov. Rick Perry signed a resolution naming the *Elissa* the "Official Tall Ship of Texas." Today she remains a worldwide benchmark of maritime preservation thanks to a devoted group of volunteers, a small but equally dedicated paid staff, and the commitment of the Galveston Historical Foundation.

Twelve thousand square feet of canvas were used for the *Elissa*'s 19 sails, each one handmade. Nat Wilson of East Boothbay, Maine, constructed the 1982 suit of sails. Jim Brink, who sewed the sails for the *Pirates of the Caribbean* movies, fabricated most of the replacements built during the last 20 years.

Above deck, the *Elissa* is remarkably close to her 1877 configuration. Below, however, safety concerns have dictated many changes. An engine and its attendant watertight bulkhead were added in 1986. Two more watertight bulkheads were added in 1990–1991 when the ship also received a new ballast system.

# Ship Shapes

Barque

Barquentine

Two-Masted Schooner

Three-Masted Schooner

Brig

Brigantine

The names of the various types of sailing ships are based on their sail plan. The *Elissa* is called a barque because she has three or more masts and is square-rigged on all but the aftermost mast. Please see the glossary for more ship terminology.

# Glossary of Ship Terms

aft—Behind, relative to the ship (closer to the stern).
amidships—The middle section of a ship. Or, toward the centerline, as "rudder amidships."
aloft—In the rigging of a ship. Above a deck.
astern—Behind the ship.
binnacle—A housing located near the helm that contains the compass.
bow—The front part of a ship.
bulkhead—A wall or partition on a ship. Some bulkheads are watertight, others are not.
bulwarks—The sides of a ship above and around the main deck that prevent crew, passengers, and cargo from being washed overboard.
capstan—A geared winch that uses bars to increase the leverage when hauling a line.
companionway—A stairway leading from a ship's deck to a cabin or accommodation below.
fo'c'sle—Crew quarters in the bow of the ship. Short for "forecastle." Pronounced *foaksel*.
fo'c'sle head—Raised deck in the bow of the ship. Located above the fo'c'sle.
fore and aft—Along the length of the vessel.
forward—In front of, relative to the ship (closer to the bow).
halyard—A line used to raise or lower a sail, flag, or yard.
hatch—A coverable opening in the deck
headsails—The jibs and staysails set forward of the foremast.
hull—The main body of a ship.
jib—A triangular fore-and-aft sail set on the stays of the foremast.
keel—Part of the ship running from bow to stern at the very bottom of the centerline of the ship.
lazarette—A storage area found at the stern of a ship.
lee—The side of the ship that is sheltered from the wind.
main deck—Largest weather deck on the *Elissa*.
port—The left side of a ship when facing forward.
quarterdeck—The aft-most weather deck on the *Elissa*. Above the officers' quarters.
saloon—Lounge area in the officers' quarters where the *Elissa*'s captain entertained guests and conducted business.
sheet—The line attached to the clew of a sail, used to set or trim the sail to wind.
shroud— Standing rigging extending on each side of a masthead to the sides of the vessel to support the mast.
skylight—Structure on the quarterdeck to provide light and ventilation to the accommodations.
spar—A wooden or metal pole, used as a mast, boom, yard, or bowsprit.
square sail—A four-sided sail extended on a yard, suspended at the middle from a mast.
square-rigged—A sailing ship that has chiefly square sails.
stanchion—A fixed upright post used as a support for a railing or the bulwarks.

standing rigging—The shrouds, stays, and backstays that are part of the system that supports and "stays" the masts to prevent them from falling.

starboard—The right side of a ship when facing forward.

stay—Part of the standing rigging to support for spars and mast. Stays support the mast fore and aft; shrouds support side to side.

staysails—The sails set on the fore-and-aft stays.

stern—The after end of a ship.

windlass—The hand-powered machinery used primarily to bring up the anchor.

yard—A long spar tapered toward the ends to extend the head of a square sail. Only the very ends of the yard are the yardarms.

## Particulars of the 1877 Barque Elissa

Cargo capacity: Six to seven boxcars of cotton or nine cars of grain
Beam: 28 feet
Depth of Hold: 16 feet
Ballast: 220 tons of 5-inch steel billet sealed in a steel ballast trunk
Tonnage: 367 gross tons, 110 net tons (International Tonnage Convention measurement)
Displacement: 976 tons maximum deep loaded, 641.45 tons currently (long tons)
Draft: 14 feet, 5 inches fully laden; currently 10 feet, 6 inches
Sparred Length: 205 feet
Length Overall (distance between forward and after extremities of hull): 155 feet
Length on Deck: 152 feet
Waterline Length: 141 feet

# About the Organization

Incorporated in 1954, the Galveston Historical Foundation (GHF) is one of the nation's largest local preservation organizations. During the past 50 years, the foundation has expanded its mission to encompass community redevelopment, public education, historic preservation advocacy, maritime preservation, and stewardship of historic properties. Today the Galveston Historical Foundation has more than 2,000 memberships representing individuals, families, and businesses across Texas, the United States, and abroad, and exerts a profound impact on the culture and economy of the island.

As a National Historic Landmark and recognized as one of the finest ship restorations in the world, the Official Tall Ship of Texas, the 1877 *Elissa*, is truly one of America's treasures. However, GHF's maritime component, the Texas Seaport Museum (TSM), has grown to include not only the *Elissa*, but also two other vessels—the 1937 wooden shrimp boat *Santa Maria* and the modern tour vessel *Seagull II*. The Texas Seaport Museum operates from the Jesse H. Jones Building, which houses TSM's offices, a maritime museum, and an immigration research center.

The Galveston Historical Foundation continues to be a driving force in the development and enrichment of the city of Galveston. The foundation is a major voice of preservation advocacy both locally and throughout the state. The Galveston Historical Foundation's many departments, programs, events, and volunteers are all dedicated to its mission: preserving and revitalizing the architectural, cultural, and maritime heritage of Galveston Island for the education and enrichment of all.

# www.arcadiapublishing.com

Discover books about the town where you grew up, the cities where your friends and families live, the town where your parents met, or even that retirement spot you've been dreaming about. Our Web site provides history lovers with exclusive deals, advanced notification about new titles, e-mail alerts of author events, and much more.

**MADE IN THE USA**

Arcadia Publishing, the leading local history publisher in the United States, is committed to making history accessible and meaningful through publishing books that celebrate and preserve the heritage of America's people and places. Consistent with our mission to preserve history on a local level, this book was printed in South Carolina on American-made paper and manufactured entirely in the United States.

This book carries the accredited Forest Stewardship Council (FSC) label and is printed on 100 percent FSC-certified paper. Products carrying the FSC label are independently certified to assure consumers that they come from forests that are managed to meet the social, economic, and ecological needs of present and future generations.

**FSC**
**Mixed Sources**
Product group from well-managed forests and other controlled sources
Cert no. SW-COC-001530
www.fsc.org
© 1996 Forest Stewardship Council

*Find Your Place in History.*